Basic Drawing Techniques

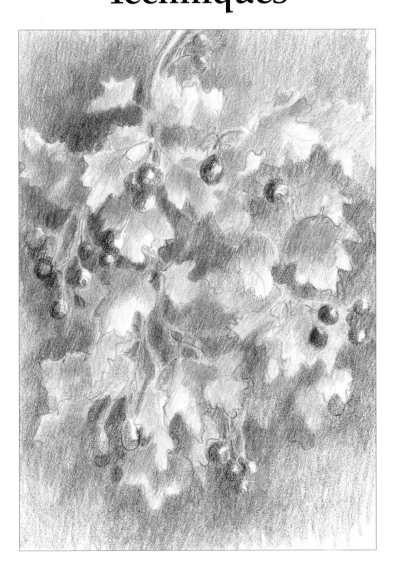

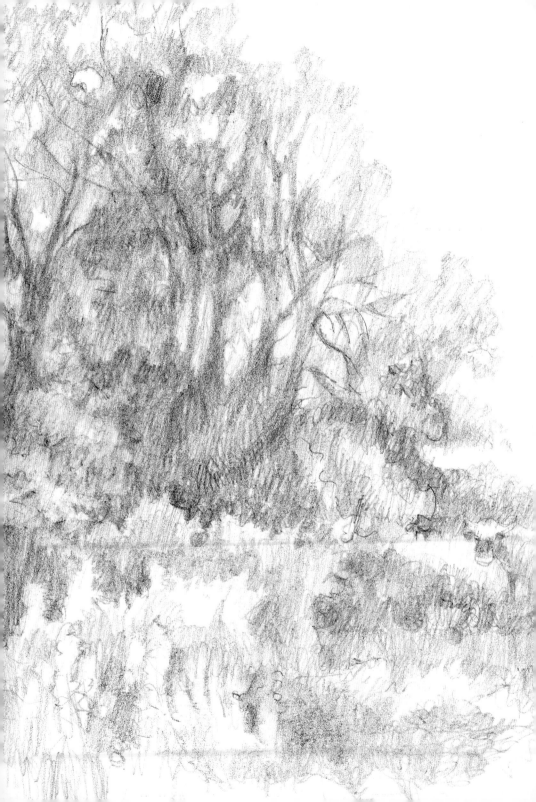

Basic Drawing
Techniques

RICHARD BOX

SEARCH PRESS

This edition first published in Great Britain 2013

Search Press Limited
Wellwood, North Farm Road, Tunbridge Wells, Kent TN2 3DR

Originally published in Great Britain 2000
Text copyright © Richard Box 2000

Photographs by Search Press Studios
Photographs and design copyright © Search Press Ltd. 2000

ISBN: 978 1 84448 890 2

The publishers and author can accept no responsibility for any
consequences arising from the information, advice or instructions
given in this publication.

The publishers would like to thank Winsor & Newton for
supplying all the materials used in this book.

Suppliers
If you have difficulty in obtaining any of the materials and
equipment mentioned in this book, then please visit the Search
Press website for details of suppliers: www.searchpress.com

*I am indebted to Rosalind Dace, my commissioning editor, for
inviting me to write this book. I thank her and all the staff at
Search Press for their encouragement and helpful guidance.
I would like to give special thanks to Winsor & Newton for
supplying the materials and equipment which I have used for
all the illustrations. Finally, I thank Pauline Garnham for her
time and patience in typing the script.*

Publisher's note
All the step-by-step photographs in this book feature the
author, Richard Box, demonstrating drawing techniques.
No models have been used.

Page 1
Haws
210 x 297mm (8¼ x 11¾in)
Coloured pencils on grained cartridge paper.

Pages 2–3
Salisbury Cathedral Across the Meadow
420 x 297mm (16½ x 11¾in)
Graphite pencils (2B and 3B) on white cartridge paper.

Page 5
Haws
297 x 210mm (11¾ x 8¼in)
Graphite pencils on cartridge paper.

Printed in Malaysia

Contents

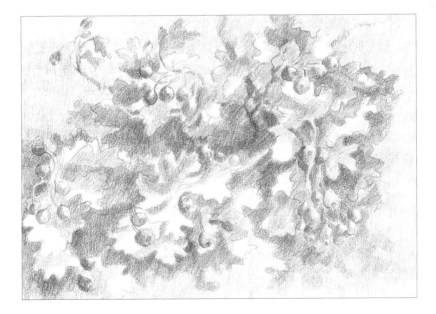

Introduction

I pray every day that God make me like a child, that is to say that he will let me see nature in the unprejudiced way that a child sees it.

Jean-Baptiste Camille Corot (1796–1875)

Does the idea of drawing fill you with dread? If so, simply say to that negative and irrelevant idea, 'not today thank you very much, I am on an adventure!' My students learn this by heart in order to dispel imagined ideas of fear of failure, ridicule and not knowing how to start. Very soon they learn to focus on the reality of the *process* of drawing as an adventure, a means of discovery and a way of loving all the beauties that nature has to offer us. John Ruskin said, 'I would rather teach drawing that my pupils may learn to love nature than to teach the looking at nature that they may learn to draw.' Now you have this opportunity.

Henry Moore also said something most useful to help us concentrate on the process of drawing: 'Drawing is a means of finding your way about things, and a way of experiencing more quickly, certain tryouts and attempts.' Notice that he avoids mentioning 'results'! End results certainly occur. However, they are dependent on the means. Once we have learnt the means – and even learnt to enjoy them – the end must come. Even when an 'end' arrives it leads us on to another. Therefore, drawing needs to be viewed as a continuing voyage – an adventure – with pauses on the way; rather like any drawing is never *really* finished, as Paul Gardner said of painting, 'it simply stops at interesting places.'

The purpose of this book is to provide both theoretical and practical help to all of you who wish to draw and learn about the wonderful nature of drawing itself. We shall be exploring the qualities of the materials and equipment we use and the surface upon which we work. We shall investigate the properties of line, tone, texture and colour. We shall learn ways of looking at the natural world so that we may see it more clearly and perceptually, in order to express our responses in each of our own unique and individual ways.

Believe it or not, we all used to draw once. Drawing is a pre-literate language. Before we learned to read, write and do arithmetic we all drew and no-one taught us. You had once started this adventure, maybe the pause between then and now is longer than you care to admit, but you are now simply continuing from whence you left it. Like the child you once were, become again absorbed, free from inhibitions and full of wonder in your exciting adventure.

Opposite
Morning Glories
265 x 420mm (10½ x 16½in)
Coloured pencils on cartridge paper.

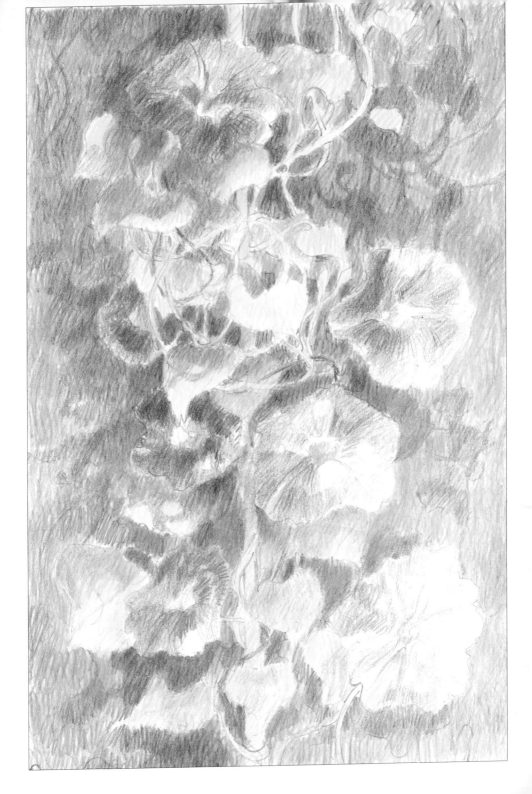

Materials and equipment

Getting started need not be expensive. You need just a few pencils, a craft knife, an eraser, some paper, a drawing board and some clips. You can add more to your work box as you become more confident.

Drawing media

Graphite pencils These are the most popular pencils for drawing. They are available in a range of leads, graded from hard (9H) to soft (9B). Hard leads usually make sharp pale marks, whereas soft leads make less precise and darker marks. All graphite leads create a shiny surface.

Pierre Noire pencils These yield a much darker tone than graphite pencils and create a matt surface. They are graded in a range from hard (H) to soft (3B).

Carbon pencils These create tonal values midway between those made by graphite and Pierre Noire pencils. They are available in a hardness range of 2H to 3B.

Charcoal This is available in stick and pencil form. Charcoal sticks, which are made in various thicknesses, tend to be softer than the pencils. Pencils have compressed charcoal cores, and are available in a range of hardnesses. Both types create a more immediate and dramatic result than any of the pencils mentioned above.

White pencils These are normally used on coloured or tinted paper; either on their own or, more usually, in conjunction with other media to accentuate highlights.

Sanguine and sepia pencils These provide a useful alternative to the white, black and grey tones made by 'black' and white pencils. Their lead structure is similar to that of charcoal, and contact with the paper is immediate.

Coloured pencils These are very popular, and there are lots of different ranges available. Most of them are transparent in nature so that other colours can be made by layering one over another.

Pastels and Conté crayons Pastels are available in stick or pencil form. Stick pastels make more immediate marks than the slightly harder pastel pencils. The marks made by Conté crayons are midway between those of pastel sticks and pastel pencils. Both media are opaque by nature, so other colours can be created by mixing them on the paper. This opacity also gives them excellent covering power. Thus they have the opposite quality of the coloured pencils.

Craft knife This is best for sharpening pencils (rather than a pencil sharpener). It allows you to form a long lead – you can then use the side of the lead to create broad marks, and the tip to make fine details.

Eraser This is used to remove unwanted marks and to identify highlights. Very soft putty erasers are best as they do not smear the drawing or scuff the surface of the paper.

Using a limited palette

More often than not I work with just nine colours – three reds, three yellows and three blues – and, when working with pastels or Conté crayons, white. All the illustrations in this book have been created from a limited palette of the following colours: Lemon Yellow, Yellow, Gold Yellow, Scarlet, Red Lead, Cyclamen, Light Blue, Ultramarine and Dark Ultramarine.

Note Charcoal, chalk, sanguine and sepia pencils, pastels and Conté crayons yield an excess dust which you will need to blow away during the course of your drawing.

Opposite
A selection of the wide range of drawing media available.

Papers

Cartridge paper This is the most usual type of drawing paper. It is available in sheet or pad form in various sizes and weights (thicknesses).

Watercolour paper This is available in a wide range of weights and in three surface finishes. These range from relatively smooth to very rough. The surface indentations in the rougher papers allow tiny white specks to appear in your drawing marks and help to create a light, airy effect.

Pastel paper This is available in numerous colours and has a grained texture. It is clearly suitable for pastels and charcoal but you can also work on it with pencils and coloured pencils. Indeed, as you are on a drawing adventure, why not try all media on all papers to discover different effects?

Equipment

Drawing board This is necessary to support the paper. You can buy ready-made boards, but a well-sanded piece of plywood or a sheet of MDF is perfectly adequate.

Clips Use spring clips to attach the paper to the board.

Easel An easel is not essential but using one does allow you to stand back from your work to monitor its progress.

Viewfinder This can be used to help you compose a picture. The photograph below shows three simple viewfinders which you can easily make yourself. Notice that they all have a regular grid, either superimposed on them or marked at the edges. Your viewfinder must be made to the same proportions as your paper (or vice-versa), so that you can use the grid to transfer the main contours of your subject on to the paper.

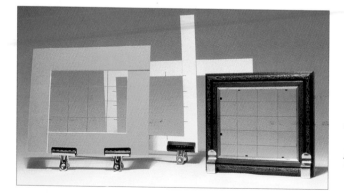

Three handmade viewfinders

The left-hand model is made from two L-shaped pieces of mountboard, glued together to form a rectangle. Fine wires, attached to the back, form of a grid.

The middle viewfinder is an adjustable one. It is made from L-shaped pieces of mountboard held together with clips. The grid consists of equidistant marks drawn along each edge.

The final viewfinder is a small picture frame with a grid drawn on the back of the glass.

Using a viewfinder

A viewfinder with a grid is an extremely useful device. Artists have used them for over five hundred years, not only to 'find their views' but also as an aid to achieve proportion.

Set up the subject and adjust the lighting until you are happy with the contrast between light and dark tones. Then, using clips to support the viewfinder in the vertical plane, adjust its position until you are happy with the composition. Here I have placed a small apple branch against a dark background and lit the apples with a spotlight to accentuate the contrast between pale and dark tones.

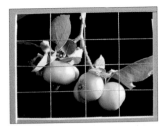

Notice how the side light creates strong highlights on all three apples and good tonal contrasts over most of the leaves.

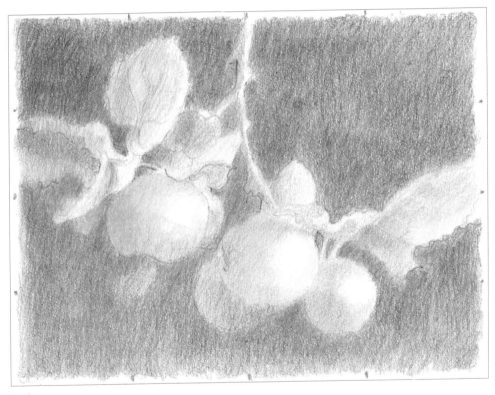

Apples
215 x 160mm (8½ x 6¼in)
Coloured pencils on cartridge paper taken from the still-life composition in the photograph above. Notice how the grid marks round the edge of the paper correspond to the grid in the viewfinder.

Pencils

Become like a child again and explore the nature of pencils and paper without preconceived ideas and in an unprejudiced way. Discover what they are like and what they like to do. Children wonder at such marvels and, with wisdom adults may reinstigate this state – Plato said, 'Wonder is very much the affection of a philosopher'.

In this chapter I show how to make different marks on the paper, I introduce you to tone and texture, then take you, step by step, through a simple graphite pencil landscape.

Making marks

The photographs on this page show how you can create different marks on the paper: you can vary the way you hold the pencil; you can work the pencil stroke from the wrist or from the knuckles; and you can work with either the tip or the side of the pencil lead.

The quality of the marks also varies with the type and grade of pencil used, and with the type and texture of the paper (see opposite).

If you hold the pencil gently at the top and work from the wrist, you can create long, pale marks.

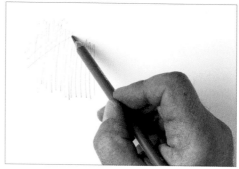

If you move your fingers further down the pencil and still work from the wrist, you can create shorter, darker marks.

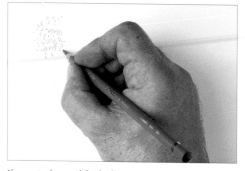

If you grip the pencil firmly close to its point and work from the knuckles, you can create very short and dark marks.

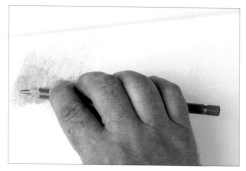

If you hold the pencil with the side of the lead touching the paper, you can make broad marks. Change tones by varying your grip on the pencil.

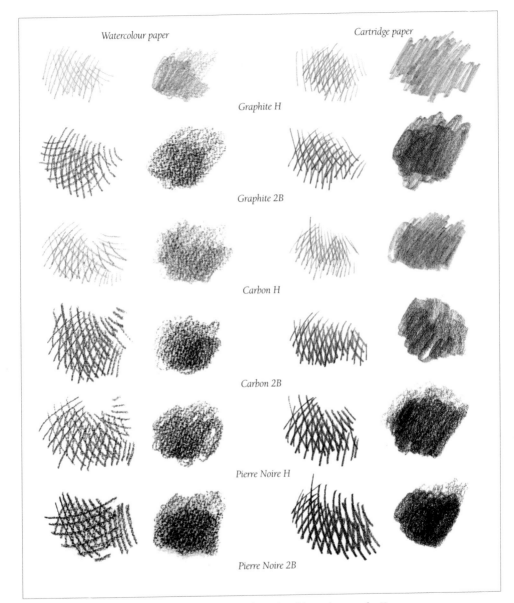

Watercolour paper

Cartridge paper

Graphite H

Graphite 2B

Carbon H

Carbon 2B

Pierre Noire H

Pierre Noire 2B

Try various pencils and papers and discover the differences in the quality of the marks you make. Here, six different pencils have been used to make crosshatching with the points, and shading with the side of the leads. The left-hand marks are made on watercolour paper, the right-hand ones on cartridge paper.

13

Tonal values

Try this exercise to develop your awareness of tonal values between the extremes of pale and dark. For this example, I used a 2B graphite pencil on a sheet of cartridge paper.

1. Hold the pencil gently at the top. Move from the wrist and shade very lightly. Try using the side of the pencil lead (left-hand column) and then its point (right-hand column).

2. Now hold the pencil in the same way and perform the same two actions as in step 1 but, this time, leave a little of the previous tonal value showing.

3–7. Continue to shade in this way from pale to dark. For each layer, gradually move your fingers closer to the pencil lead, allow your grip to become slightly firmer, and change the stroke movement from the wrist to the knuckles. Leave a little of the previous tonal value showing so that you create a tonal scale from pale to dark. Remember, one scale is made with the side of the lead and the other with its point.

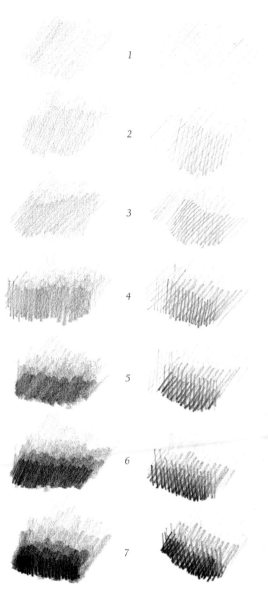

These marks, made with a 2B graphite pencil on cartridge paper, show seven layers of tone to create a gradual transition from dark to light. The left-hand marks were made with the side of the lead, the right-hand ones with its tip.

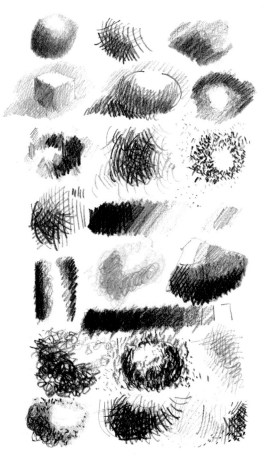

These marks were made using a variety of different types of pencils.

Tone and texture

Using as many kinds of graphite, carbon and Pierre Noire pencils as you can find, and working on different kinds of paper, develop the exercises on pages 13 and 14 to make lots of different marks.

Follow the method of making tonal values from pale to dark (see opposite). Try not to be inhibited with your marks and you will soon discover how to make a variety of effects.

When you have completed this exercise and begun to understand how to make the pencils work, you are ready to continue your adventure.

Composition

I must say a few words about composing pictures – about where to place your subject on the paper. There have been many rules and guidelines written about composition. The most favoured is to place the main feature slightly off centre; one-third in from the side of your paper, and in the top or bottom third of it. You, like many of us, will probably do this instinctively.

You must also be very much aware of the shapes you see in between the main features. These are equally important to the composition. Indeed, they are 'the powers behind the throne'!

Another important consideration is to choose a view where you see a contrast between light and dark tones and between colours. Whereas colours appeal to our emotions and are necessary to nurture our spirits, tonal values appeal to our minds and help us to make sense of things. When you are working indoors, try lighting your subject from various angles and note the different effects you can achieve.

Trees in a Landscape

Never in the world's history has there been a greater desire to escape from the technological realm of computers and electronic machines than at the present time. As we enter the new millennium we stand in greater need of the healing powers of nature than ever before. Therefore, let us turn to nature for our first subject and draw some trees dappled by the morning light.

You will need

Cartridge paper
Graphite pencils (2H to 3B)
Putty eraser
Viewfinder

1. Use the viewfinder (see page 11) to compose your picture. Then, lightly holding the top of a 2B pencil, start drawing the main contours in very pale and broken lines.

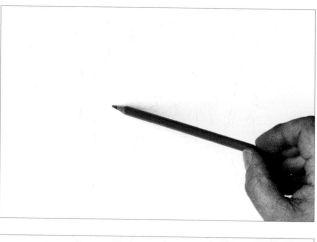

2. When all the main elements have been positioned, redefine these contours, correcting and amending them with similar pale and broken lines.

3. Now, holding the pencil nearer to its tip, use slightly more pressure to develop the contours even further. Remember that you are still in the process of finding your way around things, so do not expect to achieve absolute accuracy yet!

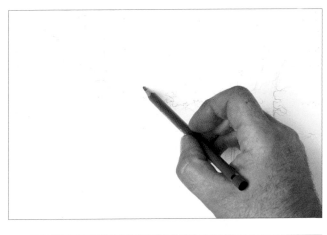

4. Half close your eyes then select and mark out all the palest areas in your composition. Still using the 2B pencil, shade all other areas of the drawing very lightly with the same very pale tone. Vary the strokes of the pencil so that they follow the rhythmic directions you see in the subject.

> **Note** *Although you have been very careful, your drawing should look vague and seemingly imprecise. You have only just started to form its tonal structure, so it could be described as very young with plenty of scope for development.*
>
> *Do not be alarmed that your first layer of shading seems to hide your initial contours. It would be most unusual to have positioned all your contours correctly at this stage. You can accentuate those that are correct, and allow the others to merge with subsequent layers of shading. Drawing need not necessarily consist of putting lights and darks within already formed outlines; it can be a whole process of construction and reconstruction of light and dark areas by which lines can be formed and reformed to help us juxtapose such tonal values. After all, as Paul Cézanne said, 'Lines do not exist in Nature'.*

5. Redefine your contours, again in broken lines, but using a 3B pencil to make marks slightly darker than your first layer of shading. Then, omitting the highlights and the lightest of the shadowed areas, shade the whole picture again with the 3B pencil, to create a tone slightly darker than that in step 4.

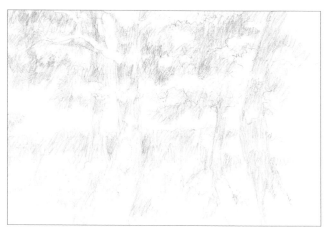

6. Still using the 3B pencil, redefine some of the contours that have merged into your previous layer of shading. Shade the whole picture a little darker, omitting the highlights and the lightest tones of the shadowed areas again, and also the not-quite-so-pale tones in these areas.

7. Use a putty eraser to identify those highlighted areas that you may have missed, or may have covered by the exuberance of your previous shading technique.

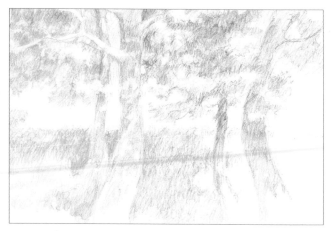

8. Now take a variety of pencils and use soft ones to identify the darker tones and hard ones to accentuate details. Use gentle touches to shade some pale and halftones which you may have missed earlier. Continue to use the putty eraser to reconstruct small highlights and reflected lights so that you achieve the effect of dappled light.

9. Continue to develop your drawing for as long as you like. Look back at each stage of this demonstration and notice that, although the drawing has never looked *finished*, it does look whole and complete at every step along the way. Remember what Paul Gardner said about a picture never being finished, 'It simply stops at interesting places'.

The finished drawing
297 x 210mm (11¾ x 8¼in)

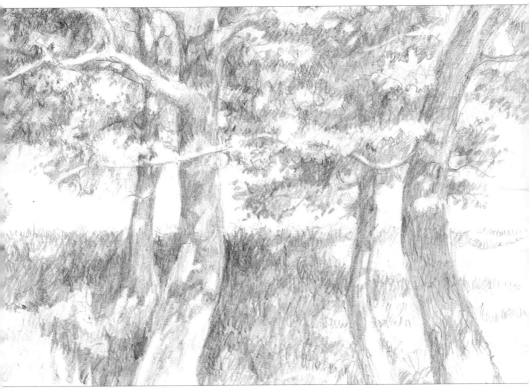

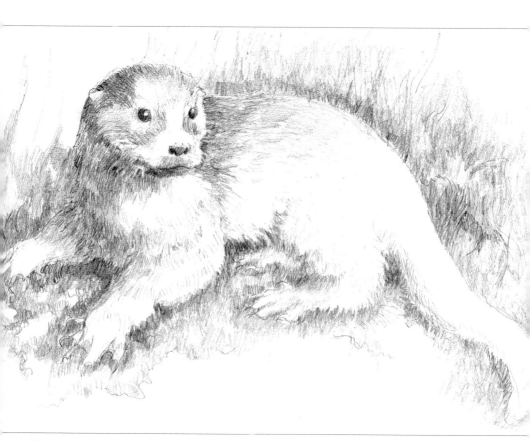

Otter
355 x 240mm (14 x 9½in)
H, HB and 2B graphite pencils on smooth cartridge paper.

This drawing and the others on these two pages, were
created by following the procedure of working from pale to
dark tones. You have already experienced that you can make
adjustments to your drawing as a whole more easily this
way, so continue to do so and enjoy the different qualities
that are offered by these materials.

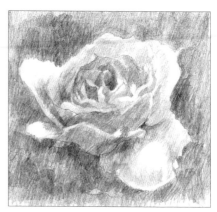

Rose
205 x 195mm (8 x 7¾in)
2B carbon pencil on smooth cartridge paper.

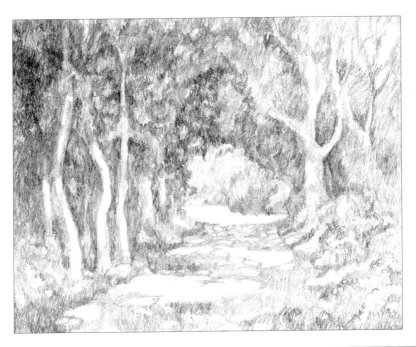

Country Lane
270 x 215mm
(10½ x 8½in)

2H through to 3B graphite pencils on smooth cartridge paper.

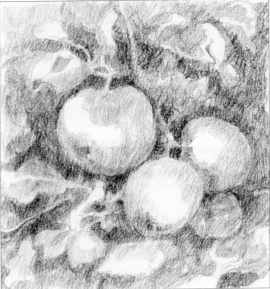

Apples
225 x 275mm (9 x 11in)
H and 2B Pierre Noire pencils on grained cartridge paper.

21

Charcoal and chalk

Now expand your repertoire and explore the properties of charcoal and chalk or white pastel. You will discover that they make more immediate marks than pencils. As before, assume the unprejudiced frankness of a child so that you may enjoy your adventures without impediments. As Stephen Nachmanovitch said, 'The most potent muse of all is our own inner child'.

Making marks

Use charcoal, in stick or pencil form, to practise making marks (as shown on this page) on a sheet of tinted pastel paper. Then use white chalk or white pastel to make similar marks. When you are happy with the basic strokes, develop them into different tones and textures similar to those shown opposite.

If you hold the charcoal stick at an angle you can create fine lines with its tip.

If you hold the side of the stick against the paper you can create broad strokes.

If you change the angle of the chalk you can create contours of varying thickness.

If you press the chalk firmly on the paper, you will notice its opaque nature.

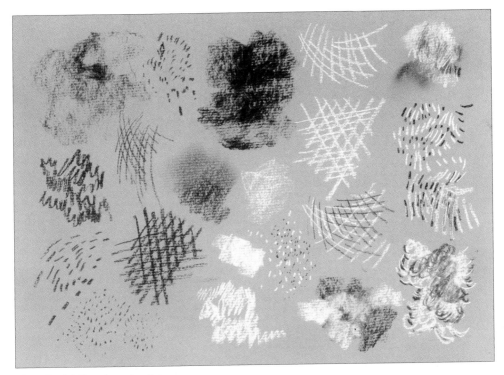

Charcoal and chalk can be used on their own or together to form a wide variety of marks.

Full-size detail from the above sheet of marks.

Tumbler and Fruit

Let us now draw a simple study in charcoal and chalk. We will employ the same principle of drawing as used for trees on pages 16–19, and gradually develop the composition as a whole from start to finish. However, this time we will be drawing on a grey pastel paper, so we shall start from a mid-toned grey and work towards the palest and darkest tones concurrently.

You will need
Grey pastel paper
White chalk or white pastel
Charcoal pencils B and 2B
Charcoal stick, medium thickness
Putty eraser

Photograph of the still life.

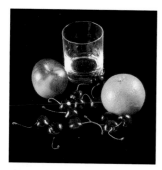

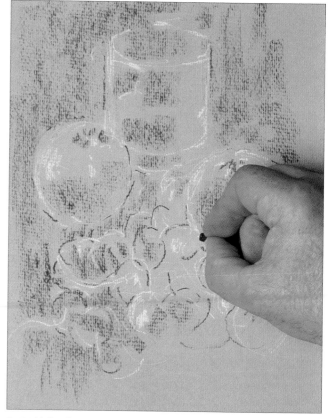

1. Use white chalk or white pastel (one tone paler than the paper) to draw the main contours in broken lines, and to gently mark in the highlights.

2. Hold the charcoal stick very lightly on its side and apply broad strokes (one tone darker than the paper) to the mid- and dark-toned areas of the composition. Use the tip to redefine some contours.

24

3. Continue to develop and darken the tonal values slightly and to define the contours. Make your marks following the contours of the images.

Note *Allowing nothing to be either too light or too dark empowers you to make tonal corrections easily.*

Use the putty eraser to modify lines that are either too pale or too dark.

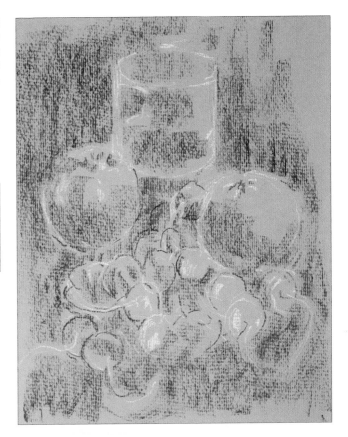

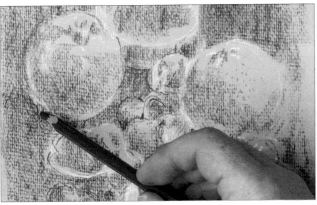

4. Use a B charcoal pencil to redefine the contours and start to develop the dark tones.

25

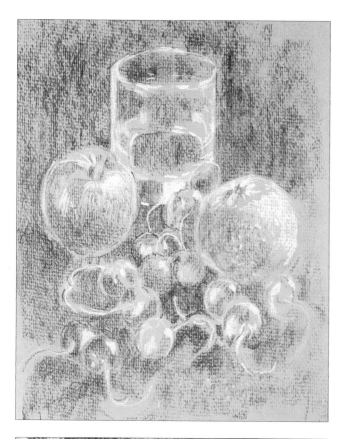

5. Use white chalk or white pastel to accentuate highlights and contours. Make adjustments to the composition if necessary – here, some of the cherry stalks have been erased and redrawn.

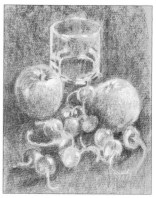

6. Begin to intensify the darkest areas using B and 2B charcoal pencils and the charcoal stick. Allow your strokes to follow the directions you see in the images.

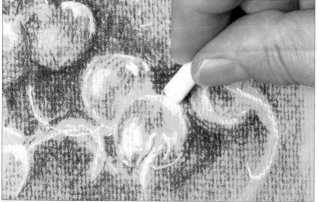

7. Now use white chalk or white pastel to develop the pale areas and the highlights in a similar way.

Opposite
The finished drawing
210 x 297mm (8¼ x 11¾in)

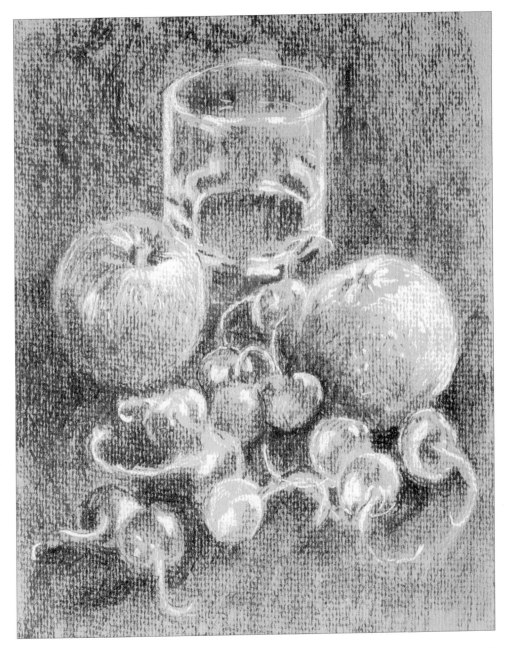

Apples and Cherries
297 x 210mm (11¾ x 8¼in)

Charcoal and chalk on grey pastel paper.

For this picture and the others on these two pages, I followed the same way of working from the given tonal value of the paper to the relative extremes of light and dark.

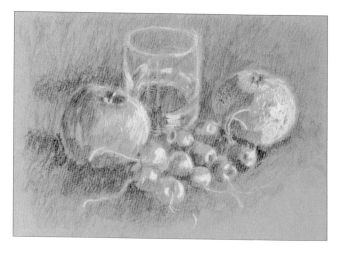

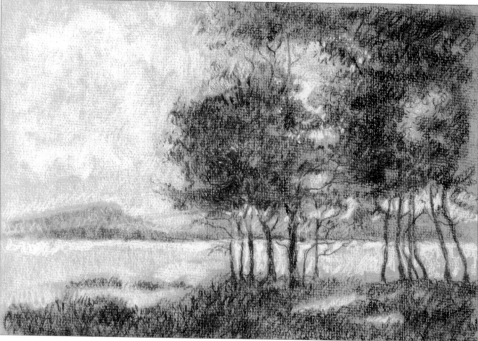

Landscape
420 x 297mm (16½ x 11¾in)

Charcoal and chalk on grey pastel paper.

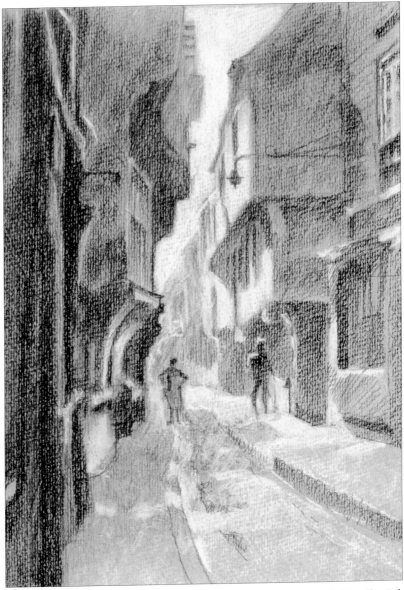

The Shambles, York
210 x 297mm (8¼ x 11¾in)
Charcoal and chalk on grey pastel paper.

29

Coloured pencils

Now you are going to explore the wonderful world of colour. Practise the colour mixing exercises opposite to prepare yourself for some enjoyable adventures ahead.

If you use just the nine coloured pencils shown below (three hues of each of the three primary colours (red, yellow and blue)) you will soon learn how to make an enormous variety of other colours including purples, oranges, greens, browns, greys and even blacks.

Mixing colours

Start your experiments by creating the colour wheel shown below. Purple, orange and green are known as secondary colours, and you will see that these have been made with specific primary colours in order to create the brightest possible hues. For example, you will notice that Dark Ultramarine and Cyclamen are closer to purple than the other blues and reds.

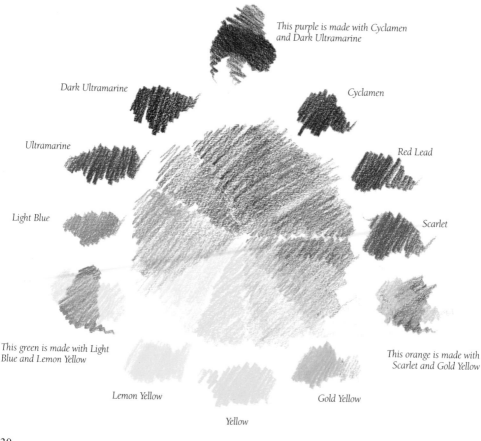

This purple is made with Cyclamen and Dark Ultramarine

Dark Ultramarine

Cyclamen

Ultramarine

Red Lead

Light Blue

Scarlet

This green is made with Light Blue and Lemon Yellow

This orange is made with Scarlet and Gold Yellow

Lemon Yellow

Gold Yellow

Yellow

Try mixing all pairs of colours and notice how the resulting hues of secondary colours vary from bright to dull. Here I show some hues of green that can be made by mixing the three yellows with the three blues.

Light Blue and Gold Yellow

Light Blue and Yellow

Light Blue and Lemon Yellow

Ultramarine and Gold Yellow

Ultramarine and Yellow

Ultramarine and Lemon Yellow

Dark Ultramarine and Gold Yellow

Dark Ultramarine and Yellow

Dark Ultramarine and Lemon Yellow

Now try mixing pairs of colours in various proportions to make even more hues. Start with the mixtures for the brightest secondary colours – here are three examples of bright orange hues made from Gold Yellow and Scarlet. Also try varying the mixes for bright greens (Lemon Yellow and Light Blue) and bright purples (Cyclamen and Dark Ultramarine).

Bright oranges: Gold Yellow and Scarlet

More red, less yellow *Equal red and yellow* *More yellow, less red*

Next practise making the dull greens, oranges and purples. These can be varied so much that some appear more brown or grey, because a vestige of the third primary colour is present in each pair of colours. For example, in the dull purples below, Light Blue and Scarlet both contain traces of yellow.

Dull purples: Scarlet and Light Blue

More red, less blue *Equal red and blue* *More blue, less red*

Browns, greys and even blacks can be made by mixing the three primary colours together. Reddish browns have more red, yellowish browns have more yellow, and greys (bluish browns) have more blue. The darker the greys, the more they seem like black. Under these examples is a colour code showing the greater and lesser amount (by your pressure on the pencil) of the particular colours used.

Cyclamen, Gold Yellow and Dark Ultramarine

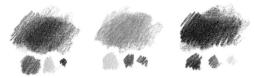

You can also make other browns, greys and blacks by mixing various hues of primary colours.

Red Lead, Scarlet, Ultramarine, Light Blue, Yellow and Lemon Yellow

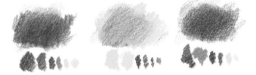

Notice that browns, greys and blacks are biased towards one or other of the primary and secondary colours, and this is also true in nature. Furthermore, you can apply such mixtures to primary and secondary coloured objects where they are dark, dull or in shadow. The examples below show how the three reds can be adjusted in this way. The colour *before* the point (•) is used all over the shape, lightly or firmly, as appropriate, to render light and shadow. The colours *after* the point are used only in the duller and darker areas, leaving the rest bright and pale.

Explore and extend these colour exercises as much as you like. The more you do, the more you will facilitate your understanding of the nature of colour mixing and how you can apply it to drawing.

31

Variegated Ivy (greens)
230 x 150mm (9 x 6in)

Coloured pencils on cartridge paper.

All the coloured drawings illustrated on these two pages follow the same principles of colour mixing which we explored on the previous page.

Adjacent to each drawing are colour codes showing the greater and lesser amount of each colour used. The primary and secondary colours shown before the point are used throughout each feature; those following the point are used only in the dark and dull areas. However, for the greys in Nanny Goat and the browns in Plums all colours are used throughout the appropriate areas.

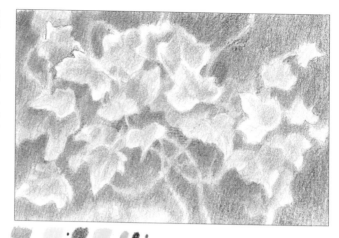

Nanny Goat (greys)
200 x 200mm (8 x 8in)
Coloured pencils on cartridge paper.

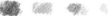

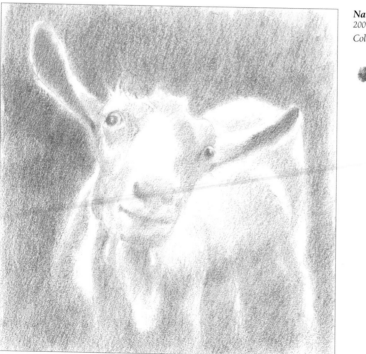

32

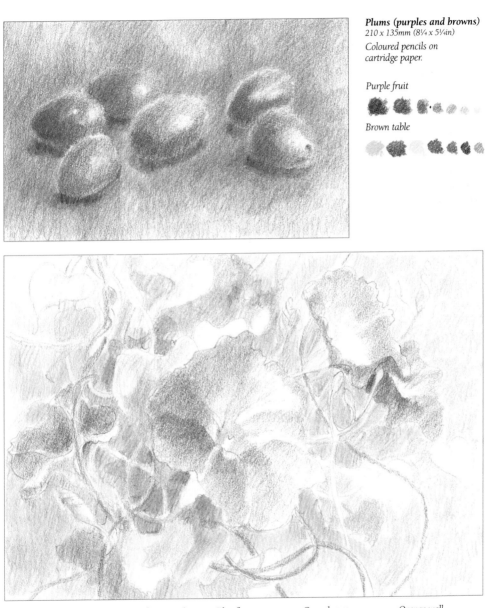

Plums (purples and browns)
210 x 135mm (8¼ x 5¼in)

Coloured pencils on cartridge paper.

Purple fruit

Brown table

Morning Glories (blues, greens and oranges)
297 x 210 (11¾ x 8¼in)
Coloured pencils on cartridge paper.

Blue flowers *Green leaves* *Orange wall*

Herbaceous Border

Goethe said, 'Flowers are the beautiful hieroglyphics of nature by which she indicates how much she loves us'. Most of us love flowers so let us reciprocate our mutual feelings with nature and devote our attentions to these 'beautiful hieroglyphics' with our coloured pencils.

My preference is to start and complete a drawing directly from nature. However, it is also possible to work a finished drawing from a detailed sketch and photographs for colour reference, which is how I composed this picture.

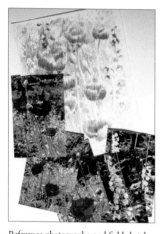

Reference photographs and field sketch.



You will need

White cartridge paper

Putty eraser

Coloured pencils: Scarlet, Red Lead, Cyclamen, Lemon Yellow, Yellow, Gold Yellow, Light Blue, Ultramarine, Dark Ultramarine



1. Use the three reds and three yellows to draw the contours of the main elements of the composition very lightly. Hold the pencils gently so that your marks are extremely pale.

2. Now use the three blues to develop all of the main contours of your composition.

Note *Although a putty eraser is generally used with graphite/ carbon pencils, it is also possible to erase very pale marks made with coloured pencils.*

3. Use all three reds to shade the poppies gently and lightly. Leave the white of the paper to indicate their highlights. Include some pale red marks in dark, dull areas of the background.

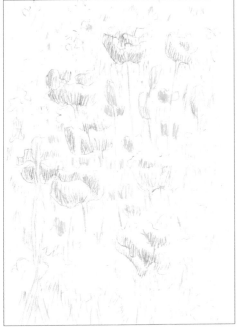

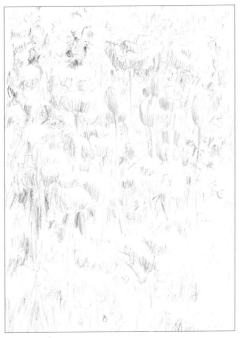

4. Now use all the yellows. Colour the buttercups and the shadowed areas of the poppies and background with Yellow and Gold Yellow. Colour the stems and leaves with Lemon Yellow.

5. Use all the blues in the same way. Colour and shade the delphiniums and all shadowed areas with Ultramarine and Dark Ultramarine. Develop the green stems and leaves with Light Blue.

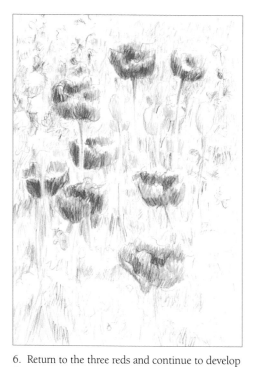

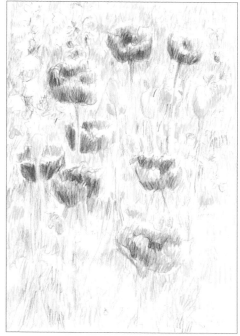

6. Return to the three reds and continue to develop the poppies with slightly more pressure. Also use them lightly in all dark, dull and shadowed areas throughout your composition.

7. Return to the three yellows and use them to develop appropriate areas.

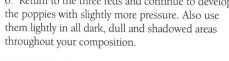

8. Finally, return to the three blues and perform similar actions as steps 6 and 7, in appropriate areas of the picture so that you develop the composition as a unified whole.

Opposite
The finished picture
210 x 297mm (8¼ x 11¾in)

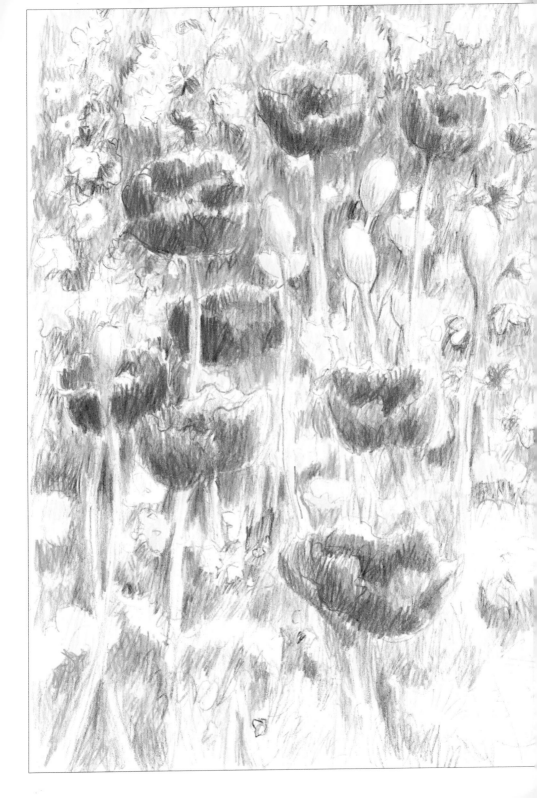

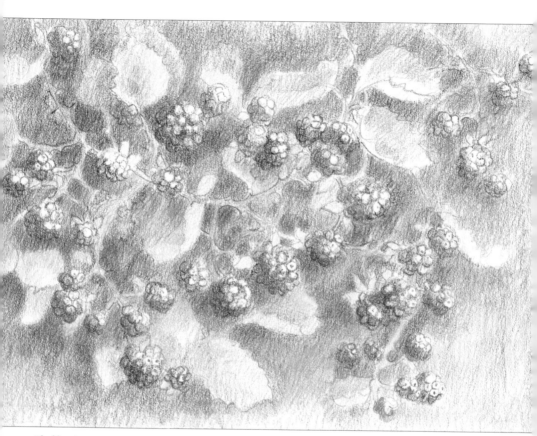

Blackberries
297 x 210mm (11¾ x 8¼in)

Coloured pencils on cartridge paper.

The same principles of colour mixing used for the
demonstration on pages 34–37 were used for this picture and
the one opposite. Notice how the different browns in both
drawings are made with all three primary colours in various
proportions.



Opposite
Beech Tree in Autumn
240 x 355mm (9½ x 14in)
Coloured pencils on cartridge paper.



Pastels and Conté crayons

Now that you have experienced coloured pencils, you are ready to explore pastels and Conté crayons. They both have powdery and opaque qualities similar to those of chalk and charcoal. A variety of colours can be made by mixing them on the paper; it is for this reason that we now need to introduce white. Try overlaying the colours so that you can see how they cover what you have drawn underneath. Such excellent 'hiding' properties are much to our advantage.

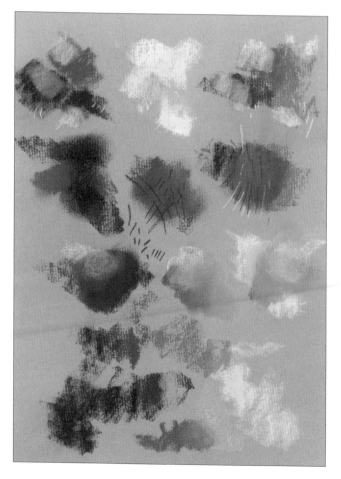

Making marks

Play with the pastels. Make different marks, experiment with colour mixing and discover how pastels behave compared with the other media you have been using.

The same nine colours shown on page 30 are also available as soft pastels and Conté crayons. Practice making marks and mixing them on a sheet of pastel paper, occasionally introducing white.

Lemon, Peppers and Tomatoes

When you practice making marks with pastels you will discover for yourself that pastels are rather different from coloured pencils but similar to charcoal and chalk. So let us take another still life as our subject for a demonstration. Remember that you can create colours and tones by *mixing* rather than *overlaying* one over another. Nevertheless, the *principle* of creating colours and tones is the same as that describedon pages 30–31.

You will need

Pale yellow pastel paper

Stick pastels: Scarlet, Red Lead, Cyclamen, Lemon Yellow, Yellow, Gold Yellow, Light Blue, Ultramarine, Dark Ultramarine, White.

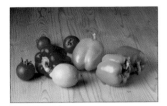

Photograph of the still life

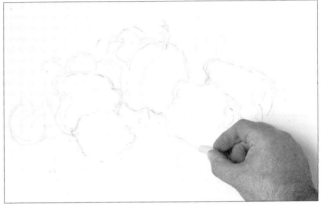

1. Lightly draw the main contours of the whole composition using the tip of the Scarlet pastel. Correct and develop the contours with Light Blue and Yellow.

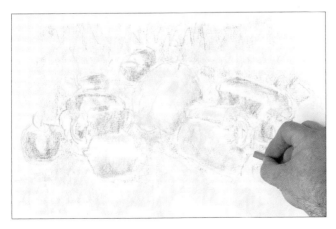

2. Use the side of the same three pastels to indicate the colours in the shadowed areas. If necessary, add more edge strokes to accentuate outlines.

3. Use the other two reds, blues and yellows to develop the colours and tones of all features in the composition.

4. Continue to develop the picture with all nine colours and white. Use more pressure to blend and merge colours in certain areas.

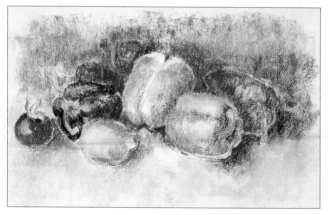

5. Darken shadows with the dark-toned pastels. Finally, accentuate highlights with pale-toned and white pastels.

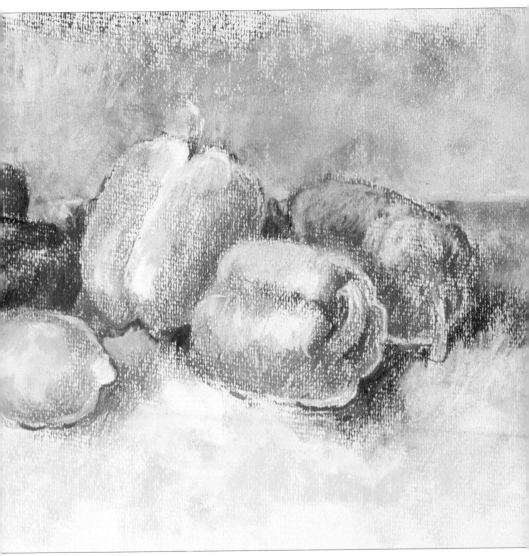

The finished painting
420 x 297mm (16½ x 11¾in)

*Notice that the 'levitating' tomato has been removed from behind the yellow pepper.
I also lightened and smoothed the background to provide more contrast with the
foreground images. The excellent hiding or covering power of pastels can obliterate
unwanted features at any time, even at this late stage.*

43

Bluebells
420 x 297mm (16½ x 11¾in)
Soft pastels on yellow pastel paper.

Opposite
Sunset
297 x 420mm (11¾ x 16½in)
Conté crayons on black pastel paper.

Notice that the sunset opposite has been drawn on black paper which shows how opaque these materials are. Notice also how certain areas in this picture are quite smooth. This is achieved by blending the crayons with the fingers. Try exploring this technique yourself and see the effect you will achieve.

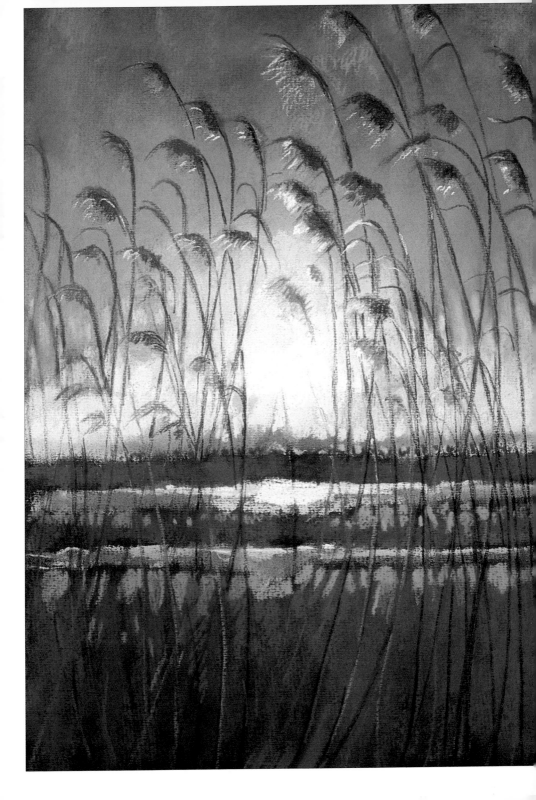

Conclusion

Now we come to the end of this book, it remains for me to wish you well for your continued adventures in drawing. I leave you with a few words from another artist writing as far back as the fourteenth century. I hope that you will realise that Cennino d'Andrea Cennini's encouragement is as relevant to us today as it was to apprentices then.

Now you of noble mind who are about to enter this profession, begin by decking yourself in this attire: love, enthusiasm, respect, willingness to follow rules and perseverance.
Cennino d'Andrea Cennini

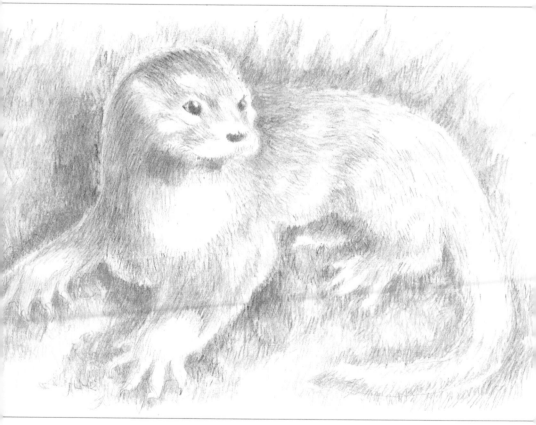

Otter
355 x 240mm (14 x 9½in)
Pencil pastels superimposed on coloured pencils.

Compare this rendition with the graphite pencil version on page 20.

46

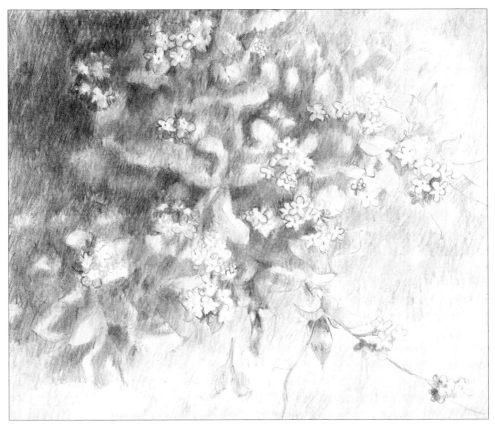

Forget-me-nots
240 x 210mm (9½ x 8¼in)

Coloured pencils on smooth cartridge paper.

I discovered these forget-me-nots growing out of a stone wall and was inspired to draw them trailing downwards in this way.

Index

Sunset
210 x 297mm (8¼ x 11¾in)
*Sanguine, sepia, white pencil and chalk
on pale yellow pastel paper.*